# SELECTED
# FABLES

JEAN DE LA FONTAINE

SELECTED

# FABLES

TRANSLATED BY
EUNICE CLARK

ILLUSTRATED BY

*Alexander Calder*

DOVER PUBLICATIONS, INC.

NEW YORK

Published in Canada by General Publishing Company, Ltd.,
30 Lesmill Road, Don Mills, Toronto, Ontario.
Published in the United Kingdom by Constable and Company, Ltd.

This Dover edition, first published in 1968,
is an unabridged and unaltered republication of the work
originally published in 1948. It is reprinted by special arrangement with
George Braziller, Inc., publisher of the original edition.

International Standard Book Number: 0-486-21878-3

Library of Congress Catalog Card Number: 68–15259

Manufactured in the United States of America

DOVER PUBLICATIONS, INC., 180 VARICK STREET, NEW YORK, N.Y. 10014

# C O N T E N T S

# SELECTED
# FABLES

## THE TWO POUCHES

"Let all the creatures gather round,"
Once Jupiter declared,
"And stand before our mighty throne
To have their looks compared.

Don't be afraid," he said, "if you
Believe that you were slighted
When you were made, let's hear it now
And we will have it righted.
Now you're a likely malcontent,
Sir monkey, have your say.
Look over all these animals
Are you as fine as they?"

"Who me? Why not? I've got four feet,"
The monkey answered smugly,
"A portrait of me, I am sure,
Would not be rated ugly!
But take a look at Brother Bear!
He hasn't one true feature!
Now why should any artist want
To paint that fuzzy creature?"

T'was thought the bear would make a claim
For a more gracious form,
But no! he boasted that his looks
Were well above the norm.
But he pronounced the elephant
A gross amorphous figure,
With ears that ought to be pared down,
And a tail that should be bigger.
The elephant's remarks were not
Outstandingly sagacious
For he maligned poor Madame Whale
As being too capacious.

Dame Ant, a self-styled giantess,
Discredited the mite.
The parley ended, each convinced
That he alone was right.

*

T'is we that bear the palm of folly;
Lynx-eyed, we find the holes
In all pretensions but our own
To which we're blind as moles.
The Lord makes men like pedlars, hung
With pouches fore and aft:
In front we air each others' faults
And stuff our own abaft.

# THE HARE AND THE
# BAN ON HORNS

The King of Beasts was gored one day
And suffered so much pain,
He swore that such mishaps should not
Occur again.
Forthwith all beasts that sported horns
From his domain were banished,
So goats, rams, bulls and cows and deer
All vanished.
During the exodus, a hare
Bethought him of his ears,
Their lengthy shadow woke in him
A host of fears.
Could not those ears appear like horns
To some official beagle?
Or might they not be equally
Illegal?
He went to see a cricket friend.
"Neighbor," he said, "Adieu!
The ban on horns will soon include
My long ears too.
Even," the quaking hare went on,
"If I should have them pared
As short as any ostrich's,
I'd still be scared!"
The cricket snorted: "What, those horns!
You take me for a clod!
Those ears were plainly fastened there
By God."

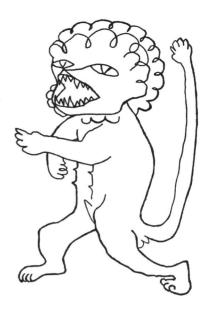

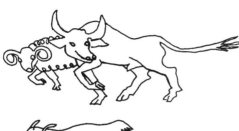

"No," said the hare, "The court has ways
To make an ear a horn.
What use to say I'm hare, they'll prove
I'm unicorn.
They'll disregard my evidence
As coming from a dunce.
Alas! There's no way out except
To leave at once!"

# THE RAT AND THE ELEPHANT

No Frenchman, I think, was ever born
Who could keep from blowing his own horn.
A shopkeeper whose rating approaches zero
Will put on the airs of a national hero.
Furthermore, we are uniquely benighted
In that our conceit is so short-sighted.
The pride of the Frenchman fogs his brain,
Though it burns less hot than the pride of Spain.
Here I will show in a little story
The usual end of such vainglory.

*

A tiny little rat
Said nastily, "What's that?"
As an enormous elephant serenely lumbered
In full regalia, heavily encumbered,
Carrying in a three-deck howdah the menage
Of a great Eastern queen on pilgrimage.
The queen had brought her dog and cat and monkey,
Her parrot, aged nurse and many a flunkey.
The elephant inspired oh's and ah's
From all except the rat. "Why this applause
For an old heap that makes the babies cry?
Does bulk connote superiority?
Or is the human race
Agog merely because he takes up space?
We rats, though small, believe the elephants
No better than ourselves!" Before he could advance
This argument, the queen's cat
Leapt from her cage. Whereat the rat
Learned speedily in just what terms
Rodents are not the peers of pachyderms.

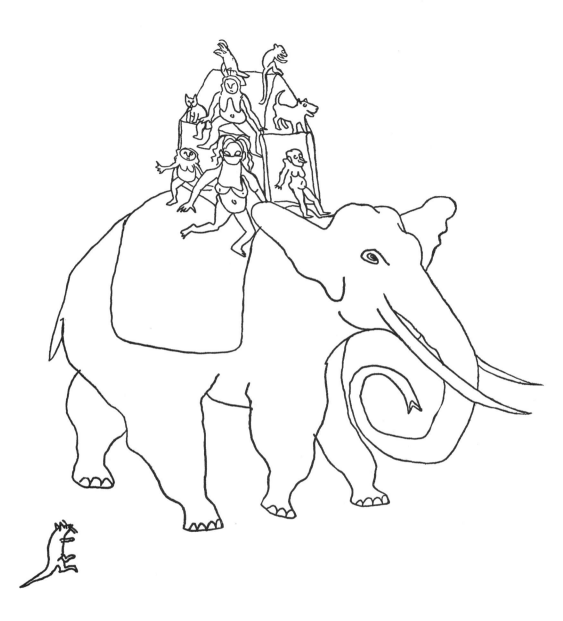

# THE LION IN LOVE

Ages ago when beasts could speak
Some hoped to join the human clique,
Notably lions. And with reason —
They equalled men, in that far season
In brain and brawn, and what was more
Could really roar.

Thus when a lion of high degree
Was passing through a meadowy
Place and saw a shepherdess
Whom he was avid to possess,
He went at once to ask her father.
That good man balked: for he would rather
Have had his pretty daughter marry
Someone less scary.

It seemed hard lines to let her go,
But then he thought if he said 'no'
He might wake up to find some morning
That she'd eloped without a warning.
He knew his child was ever keen
For people with a kingly mien,
And had her cap set, that was plain,
For a long mane.

Afraid to bring things to a head
By ousting him, the father said:
"My daughter is delicately fashioned.
As soon as you become impassioned
You'd likely wound her with your claws.
So kindly have on all four paws

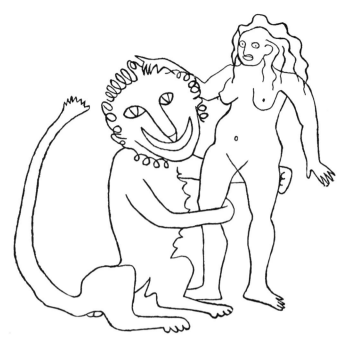

The talons trimmed. One other issue:
If this young girl is going to kiss you
With any ardor, she must be
Freed of all anxiety.
So for your own enjoyment, while
You're at it, let them file
Your teeth." The lion, love-demented,
Consented.

Behold him now without his teeth,
Without his claws, an empty sheath!
With all his native weapons gone
The helpless lion was set upon
By hounds that easily outmatched him.
They dispatched him.

*

Ah love, whoever bows to you
Should bid his sanity adieu!

# THE WAR BETWEEN THE RATS AND THE WEASELS

Weasels were ever foes
Like cats, of all ratkind.
And their long spines would wind
Through ratholes, I suppose,

To stalk the prey to his bedroom
Except that every rat
Secures his habitat
With insufficient headroom.

One year when there were swarms
Of rats to draw upon,
Their king, one Ratapon,
Issued a call to arms.

The weasels bravely swivelled
With banners to the fray.
Neither side, they say,
The other quite outrivalled.

'Twas hard to make appraisal;
Gardens were red with gore,
But infinitely more
Rat-blood was shed than weasel.

Bemired with battle-stain,
Meridarpax, Artarpax, and Psicarpax,
Their champions, named from epics,
Harangued the rats in vain.

They saw they'd lost the gamble
And could not hold their ground
And so they all turned round
In panic, skimble-shamble.

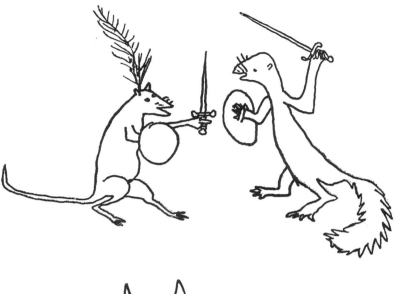

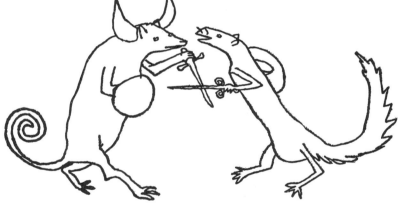

Each flew to save his skin,
Verminous Tommy Atkins
As well as noble ratkins
Who were the first done in.

The rank and file got off
By squeezing through the porthole
Of any handy rathole.
But their leaders could not doff

Their towering hats with plumage,
Their aigrettes or curvaceous
War-horns and panaches,
Which they wore to drum up homage

From rats of lower status
(Or possibly to make
The weasel legions quake).
This garish apparatus

Caused the death of many,
For with ornaments topside
They found they could not hide
In any nook or cranny.

While rats of the second water
Easily slipped away,
The aristocrats that day
Were subject to a slaughter.

\*

The magisterial headdress
Is a burden none too light.
Whenever things are tight
It's apt to slow one's progress.

Then the man who sports the cap
Of authority is stuck.
The nobodies can duck—
He has to take the rap.

## THE MOUNTAIN'S DELIVERY

A mountain having labor
With clamor rent the air.
The neighbors who came running
Predicted she would bear
A city broad as Paris
Or at least a manor house,
But at the crucial moment
The mountain dropped a mouse.

*

How like so many authors
Who say they'll set to paper
A vast Promethean epic
But all that comes is vapor.

# THE POT OF CLAY
# AND THE POT OF IRON

Said the iron pot
To the pot of clay,
"Why not travel
With me away?"

Said the pot of clay,
"That's fine for you!
Your iron skin
Will see you through.

"But as for me,
It's a different matter.
It takes so little
To make me shatter.

"You'd be bringing me home
In little chips-
I'll hug the hearth,
You take the trips."

"But I'll cover you
With a heavy wrap.
Whatever threatens,
I'll take the rap,"

Said Metalware
To Earthenware,
And lured him out
On the thoroughfare.

Going clinkety-clonk,
Like a three-legged colt
Knocking together
At every jolt,

They'd only journeyed
A little way
When disaster loomed
For the pot of clay,

And before he could ask
The iron pot
To temper the pace
Of this terrible trot,

With a smash and a crash
He met his fate
Against the flank
Of his traveling mate.

So seek out friends
With similar hides
If you don't want to shatter
Against their sides.

## THE DONKEY AND THE LAPDOG

The donkey figures he will find
Love and admiration faster
If he tries to kiss his master; —
This goes through his inmost mind:

"That lapdog, there, because he's trick
Is living like a little sister
With the missus, with the mister.
I get beaten with a stick!

"What does he do, the pampered pup?
He lifts his paw, they kiss his puss.
If that's the way to have a fuss
Made over you, I'll practice up."

When Mister seems affable enough
The donkey comes up clop, clop, clop
And pastes his lord a tender bop
Right to the jaw with a dirty hoof.

To ornament the love affair,
The donkey adds a gracious touch
To his muscular approach
By carolling a tender air.

"Pah, what a kiss! Ouch, what a wail!"
The master snorts. "Ho, varlet, bring
The stick." The donkey starts to sing
A different tune. Thus ends the tale.

<div align="center">*</div>

Never let us force our talent
Or we'll lose the magic touch.
A sodden oaf, however much
He strives, cannot become a gallant.

Only God's favorites are able
To take the gifts of life with grace.
That's a fact we'd better face
Or be the donkey of the fable.

## THE HEN THAT LAID
## THE GOLDEN EGGS

No better fable was ever written
For those whom the money bug has bitten
Than that of the man whose hen could lay
A golden egg for him every day.
He cut her open from stem to stern
To get the goldmine, only to learn
That his hen inside was like every hen
And he, more the fool, was poor again.

Many a duffer these days will euchre
Himself right out of a pot of lucre
By caring too much about the stuff.
So always remember, enough's enough.

# THE STAG AND THE VINE

Hotly followed by hunter and hound,
A stag in mortal danger found
A shelter of leaves in a vine that grew
Unusually high from the ground.

He was safe. As soon as the men turned to
And cursed the dogs and ceased to pursue,
The heartless stag, with no thought for the vine
That saved him, began to chew.

But the hunters heard the munching sounds.
They summoned back the pack of hounds.
When the stag again returned to the vine
He was dying of his wounds.

"Alas, let ingrates ponder well
My rightful fate," said the stag, and fell.
And he moaned in vain to dogs and men
As they moved in for the kill.

<p style="text-align: center;">*</p>

Image of all ingratitude
Was the hapless stag, the spirit rude
That brings to bear on its benefactors
A cavilling attitude.

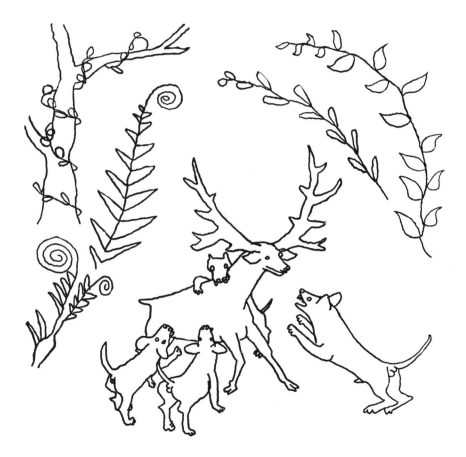

# THE CAMEL
# AND THE DRIFTWOOD

### I. THE CAMEL

The first to discover the camel
Fought shy of the new-fangled mammal.
The next was less scared,
And the third fellow dared
To throw on the camel a trammel.

### II. THE DRIFTWOOD

Some shore watchers raised a great hue,
That a vessel of war was in view.
Then they thought 'twas a sail,
Then a gig, then a bale.
At the end only driftwood hove to.

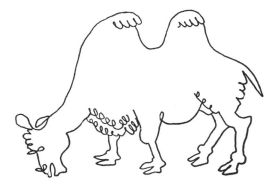

### III. ENVOI

Dear reader, the distant or strange
Shrinks fast as it comes within range.
The most jaunty of men,
Heard again and again
Will jingle like very small change.

# THE LITTLE CARP AND THE ANGLER

One day an angler by a brook
Got his hook
Into a carp no bigger than a minnow.
"Hello!"
He said, as he assayed the size
Of his prize,
"You certainly will not make a feast
But it's a start, at least,
Of one. Into the creel you go!"
But then a fishy voice said, "No!
I'd look like half a bite upon a platter!
Catch me later.
When I'm a full-grown marketable carp
If you look sharp,
Some customer will turn out half his wallet
To please his palate!
You'd have to pull a lot like me, what's more,
Up on this shore
Before you'd have sufficient little fish
To make a dish.
And still we'd be, no matter what amount,
Of small account."
"Account! Who cares about accounts? My friend,
This is the end!
I've had enough of your peculiar reasoning.
On with the seasoning!
Tonight you'll sizzle in the pot
Full-grown or not!"

*

34

If you let a fingerling back in the stream,
He will probably grow fatter.
But to catch him when he's an older fish—
That is a different matter.
Like the bird-in-hand, in the proverb,
A little fish on the hook,
Is worth a lot more than a couple
Of fish in the brook.
So don't succumb to the lure of
Catch-Me-Later-Somehow,
If you're absolutely sure of
Eat-Me-Now.

# THE JAY IN
## PEACOCK'S FEATHERS

A jay puts on his back and head
Feathers a moulting peacock shed,
Thinking this will be a handy
Way to play the jack-a-dandy.
Shameless in his masquerade
He joins the peacocks on parade.
Presently he's recognized.
Our impostor's much surprised
To find himself the laughing stock
Of every fashionable cock.
They hector, harry, heckle, hiss him,
Ridicule, and finally dress him
In a raffish mess of plumes.
When the spurious peacock comes
Seeking refuge in his family,
He's thrown out, he was so homely.

*

There are birds about today
Who remind me of that jay
Tricked out in the very stuff
Their betters have seen fit to doff.
Such a one's a plagiarist.
Myself, I have no interest
In the gentle art of cribbing
So I'd best desist from ribbing.

# THE EAGLE AND
# THE OWL

The hoot owl and the eagle
Arranged an armistice,
Embraced like long-lost brothers
And gave solemn guarantees,
The king by all that's regal,
The owl by all that's owlish,
That neither one would polish
Off a fledgling of the other's.

"But," asked the bird of Minerva,
"Would you recognize my infants?"
The eagle replied: "No."
Said the melancholy owlet,
"If that indeed is so,
They're hardly worth preserving;
I foresee that their existence
Will end upon your palate.

"You're king, so you can't tell
One from another item.
Kings are in this like gods:
No matter what we say
They only know one stratum
Made of identical clods.
No, I'll have to say farewell
To my young if you pass their way."

"Describe your babes or show them,
I'll give them a wide berth,
I swear I will," said the eagle.
"They're the prettiest things on earth,"
Claimed the owl, "The sweetest, best,
And that is how you'll know them.
So don't you cause the Angel
Of Death to come to our nest."

In time, the Lord allotted
To the owl some little chicks.
And the eagle was on a foray
One evening for edible morsures,
And quite by chance he spotted
In the murky niche of a quarry,
Or a ruin, I don't know which,
Some hideous little monsters.

"These are not budding owls,"
Averred the courtly cannibal,
No bird to scrimp on meat,
"With their melancholy scowls
And their shrewish caterwaulings.
Let's shake a royal mandible!"
The owl found only feet
When he came to get his darlings.

He called on heaven to scourge
The killer that caused his woe.
"You have yourself to blame,"
He was told, "Or the common urge
To admire whatever's the same
As ourselves. You drew an ideal
For the eagle, so how could he know?
Not a single trait was real!"

## THE MAN AND THE
## WOODEN IDOL

A certain infidel kept an idol,
One of those gods of wood
Who's carved with ears, but never hears;
Though the heathen believed it could,
In time, arrange for his luck to change
And thus repay his trust,

For easily he could be caring for three
On what the idol cost.
He would lead to slaughter and burn at the altar
Garlanded bulls and ewes;
There was never a myth more pampered with
Succulent barbecues.
For all this oblation, no melioration
Occurred in his circumstances;
No fortunate deal, no turn of the wheel,
No dice, no inheritances.
His only reward was that all untoward
Events found him in the middle.
Though his coffers ran dry, he continued to ply
With goodies his worthless idol.
At last aggrieved at having received
From his long sacrifices
Nothing whatever, he took a lever
And smashed the god to pieces.
When he found its hold was full of gold
The heathen said to the deity:
"Not a single sou did I get from you
While you battened on my charity.
You are like the world's congenital churls,
Hapless, coarse and dumb
Whom only a knout will induce to give out.
Now go away from my home.
Find another shrine: when you lived in mine
You got fatter and fatter and fatter
While I got poor. It was time, I'm sure
To revise my view of the matter."

# THE DONKEY AND THE RELICS

A donkey who carried the holy relic,
Thought he was being adored by the public.
He struck what he thought the right
                              pose for such eminence,
Accepting with charm the canticles and incense.
A bystander noted his delusion and said:
"Sir donkey, you let things go to your head.
They're not greeting you but the blessed image
In rendering all these hosannas and homage.

*

When we bow to a judge who's an ignorant hack
We salute not the man, but the robes on his back.

# THE OLD MAN
## AND HIS CHILDREN

An aged man ready for his reward,
Handed his children a length of plaited cord.
"Let's see if you can break these strings I've tied
Into a rope. After you three have tried,
I'll tell you how to make the knot, dear sons."
The eldest tugged at the rope and said at once,
"I yield to stronger hands." Whereat his brother
Braced himself up and tugged, and then the other,
The youngest, had a chance to try his hand.
Their efforts were useless; not a single strand
Was broken in the interwoven length.
"Weaklings," the father said, "I'll match my strength
With yours." They smiled, mistaking their father's words
For irony. Then he untied the cords
And broke each separate filament easily.
"Apply this lesson to our family,"
He said. "My sons, be bound by love. Remain
United." He did not talk to them again
Until the end, but with his dying breath
He said once more, "Beloved children, Death
Has summoned me. I go to join my fathers.

Promise me this: that you will live as brothers.
Farewell." Weeping, each son came to his side,
And took his hand and promised. The old man died.

The sons inherited a large estate
With various titles to negotiate.
Creditors threatened and a neighbor sued.

The trio countered but their brotherhood
Was brief as it was rare; self-interest
Destroyed the bonds of kinship; avarice
And greed set up a chain of trouble
Which legal counsel only served to double.
So when, at last, the moment came to bring
The estate to court, chicanery was king.
The judge reported to the quarrelling heirs
Unfavorably on some of their affairs.
Then creditors and neighbors came to court,
And won, here by default, there by a tort,
And since the brothers' counsel was not joint,
Where two would hold, the third would yield the point.
When all was lost, they thought, alas, too late,
About the strands that broke when separate.

# THE FOX AND THE MASK

Fame's the most specious of integuments,
No deeper than the make-up of a mime
Which the idolatrous public, time after time,
Will raise to pinnacles of prominence.
The average ass reacts by outward sense;
The fox, on the other hand, will peer and sniff
Behind the mask, and turn it round, and if
He thereby finds sufficient evidence
That the great figure's an inane facade,
He will repeat the verdict he let fall
Upon a hero's huge and hollow bust.
He praised the art and added: "A splendid head!
Pity it has no brains." A test we all
Might use for masks in whom we place our trust.

# THE MISER WHO
# LOST HIS TREASURE

If you never enjoy it, it's not worth having!
I ask the fellow who's always saving
And socking away every cent he can,
Why he's better off than another man.
If your life is a string of painful economies,
You're as much a pauper as old Diogenes.
That's my opinion: and here, for good measure,
Is Aesop's fable of the cached treasure.

*

There was once a miser with a fist so tight
He seemed to be waiting to see the light
Of reincarnation to sample his gold,
Of which he possessed amounts untold.
Or they possessed him: for in order to hide it,
He'd buried his wealth and his heart beside it.
And now, poor fellow, his only delight
Was to chew on the thought of it, day and night.
The place where it lay was his personal shrine;
If he came, if he went, if he ate or drank wine,
There was hardly a moment his fancy was not
Fixed on that particular spot.
He sauntered so frequently there to visit,
A gravedigger saw him, and guessed some deposit
Of value was hid, which he then disinterred
And carried away without saying a word.
When our miser returns, and finds nothing there
He cries, and he groans, and he pulls out his hair.

A passerby asks him the cause of this seizure.
He answers: "My treasure! They've stolen my treasure!"
"Stolen from where?" "From next to this stone."
"Did you think that your homestead would be overrun

By foreign invaders, to take it so far?
Why didn't you keep it at home in a jar?"
Inquired the bystander, "Then you could weigh
And count it all up every hour of the day."
"Every hour!" said the miser. "You don't understand.
Do you figure that cash comes as easy to hand
As it goes? My money I never took out!"
Said the other, "Then what are you howling about?
If your money was something you never would touch,
Put a stone in its place; you'll enjoy it as much!"

## THE TWO DOCTORS

A Dr. Cheer and a Dr. Gloom
Were summoned to the same sickroom.
"He'll die," said Gloom, "I greatly fear."
"He'll get well," said Dr. Cheer.
The man agreed to follow Gloom,
And soon was lying in his tomb.
"Just as I thought," said Gloom. Said Cheer,
"If he'd hired me, he'd still be here."
They both did well by the patients doom,
Dr. Cheer and Dr. Gloom.

# THE FROG AND THE RAT

"Who aims to cheat a friend
Gets cheated in the end"—
From Merlin we inherit
Those words of force and merit;
If they seem stale, I'm sorry.
Now to the main story.

\*

A sleek and succulent rat,
Encased in rolls of fat
From the rich nourishment
He took even in Lent,
While sunning by a bog
Encountered Madame Frog.
"Come home with me to dine,
I've something extra fine."
He never hesitated,
Till she expatiated
On the profits she was sure
He'd gain from such a tour—
Learning of the uncommoner
Terraqueous phenomena.
Some day he'd tell his tots
About these scenic spots
And fill them up with stories
Of foreign types and mores,
The government he'd found
Prevailing in the pond.

The frog expressed some doubt
That he could swim without
A helping hand, but she
Soon found a remedy
By taking a reed for tether
To tie their feet together.
As the frog began to tow,
She headed straight below,
Straining to reach the bottom;

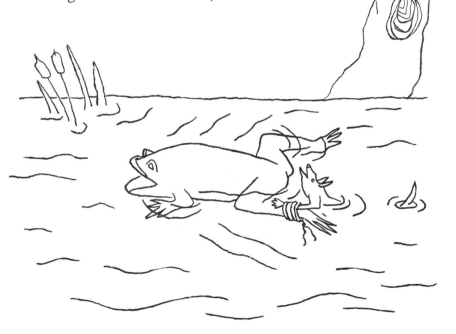

For our perfidious Madame
Meant, in disregard
Of the law and her sworn word,
To tear her guest apart
And eat the liver or heart.
Already she thought with glee
Of how juicy he would be.
The rat piteously invokes
The gods, his hostess croaks
Some sadistic jest.
The victim does his best
To free himself from her,
And in this tug of war,
A hawk, on routine flight,
Hovering, catches sight
Of the unavailing splatter
The rat makes in the water.
He swoops upon the prey;
While bearing it away,
He finds he's also got
A string and frog to boot.
To the hawk, the double killing
Is naturally thrilling,
At one blow to enmesh
A meal of fish and flesh.

<p style="text-align:center">*</p>

How often we get stopped
By the ruses we adopt.
Treachery, sooner or later,
Backfires on the traitor.

## THE FARMER
## AND HIS SONS

Work with care and diligence:
You'll not lack for pounds or pence.

\*

A wealthy farmer e'er he died,
Called his sons to his bedside

Secretly: "Don't sell the land
Our sires have taken pains to hand
Down to us," he said, "for there
Is treasure here. I can't say where,
But if you search, if you hold fast,
You will find it at the last.
When your crops are gathered in
Take your shovels and begin
To stir up every inch of land.
Leave no corner that your hand
Has not turned over more than once."
When the father died, the sons
Started digging here and there
And everywhere. Thus in a year
Their crops improved in such a measure
They reaped rewards, if not a treasure.
The old man surely plotted well
To prove that Work is Capital.

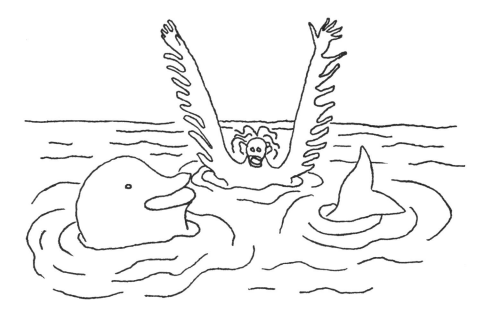

## THE APE AND THE DOLPHIN

It was the rule in ancient Greece
To take, when going overseas,
Monkeys or dogs or some such small
Entertaining animal.
A certain vessel, with a shipment
Of people, pets and their equipment,
Hard by Athens struck a reef.

The travellers would have come to grief,
But dolphins undertook to save
All humans from a watery grave.
(Dolphins, of all the kingdom finny,
Are friendliest to man, says Pliny.)
The story is, a certain ape
Was also counting on escape:
Thanks to his semi-human look
A dolphin easily mistook
Monkey for man, and let him ride
Out of the raging waves astride.
(He sat so gravely there that one
Might think him a famous baritone.)
The dolphin was about to land
His passenger upon the sand,
And asked by chance, "Is your address
Athens?" Replied the rider, "Yes,
I'm well known there. If you've some claim
To press in Athens, use my name.
We're in the highest social ranks,
My cousin's Judge." "Why, many thanks,
And do you know," inquired the dolphin,
"Piraeus? Do you go there often?"
"We're bosom friends," replied the ape,
Not knowing Piraeus was a cape.

\*

(How like the ubiquitous blow-hards
For whom the town of Vaugirard's

As far as they'll ever get from home,
And so they get it confused with Rome,
And talk of what they've never seen
Cackling like a barnyard hen.)

*

The dolphin laughed, and, turning round,
Stared at the ape; and when he found
That he was rescuing a mere
Animal, he dumped it there
And searched about the ocean thinking
To save a real man from sinking.

# THE SHEPHERD AND THE SEA

A man who lived by the briny deep
Near Amphitrite, Goddess of Ocean,
Survived for years by keeping sheep,
A task that required little exertion.
 He was fairly poor
 But his living was sure.

Then, lured by the wealth of overseas trade
That came to the coast, he sold his flocks
And juggled his funds, putting all he made
In cargoes that foundered on the rocks.
 Now he was poor
 As never before.

So he went to work, having no resources,
As a keeper of sheep; where a while ago
He had fancied himself a shepherd like Thyrcis
Or Corydon, he was now Pierrot,
 Master no more
 Of flocks by the shore.

He saved, and again bought sheep for his fold,
And he used to say, when a gentle breeze
Wafted ships to the beach: "If you want gold,
I'm not your man; oh, girls of the seas,
 My money's ashore
 Forevermore."

This tale was not invented for pleasure.
I've drawn from life the truth, as it seems
To me, to show what a paltry treasure
Is wealth that glitters only in dreams.
 A cent that's sure
 Is worth more.

Let us be deaf to the sea's clamor
That speaks to our dreams of avarice.
Where one can thank, ten thousand blame her
For storms, and tempests and piracies.
 Better by far
 To stay as we are.

# THE ASS AND THE DOG

For beast, as for man, to help when we can
Is almost a law of nature.
An ass defied it, I don't know why,
For he's a good enough creature.

With the dog his friend, no thoughts in his mind,
The ass walks, followed by master.
When he sleeps, the ass starts munching grass.
No thistles in this pasture!

For want of thistle a feast can fizzle—
But let's not be invidious—
I'll pass up thistle today, thinks Ass:
Why be so fastidious?

"Friend, will you please get down on your knees,"
Says starving Dog, "so I
Can reach the bread basket?" No use to ask it,
Ass makes no reply.

He's afraid he might miss out on a bite,
So he answers Dog at last:
"Old pal, you will sup, when master wakes up,
Till then I suggest you fast."

On exchanging these grim pleasantries,
They catch a glimpse of a wolf.
They can tell as he hurries out of the forest
That he is hungry himself.

Ass gives a yelp to Dog for help,
But he stands pat, refusing.
"Old pal," he cracks, "I suggest you make tracks,
Till Master finishes snoozing.

He'll wake up soon. Turn around and run.
If Wolf catches up, be bold.
Smash his jaw with your newly-shod paw,
Believe me you'll knock him cold!"

During this speech, Wolf gets in reach
Of Ass and chokes him to death
Without batting an eye. And that is why
Mutual aid is my faith.

# THE SATYR
# AND THE WAYFARER

A satyr, his many children,
And wife sit 'round the cauldron
Deep in their savage den.
The family is going to dine
Upon a meal of soup.
They have no spoons to sip
But take the bowl from lap
Directly to the lip.
They have not even rags
For curtains or for rugs;
Moss is their only chair,
But still they eat with cheer.
Into the cavern runs
A man to escape the rains.
Unexpected, for sure,
The wayfarer's urged to share.
No need to ask again;
E'er he will begin
To satisfy his hunger
He blows on each cold finger,
Then with his next breath,
On tit-bits in his broth.
The actions of his guest
Leave the satyr aghast.
"What should we infer
This exhalation's for?"

"I blew, as I recall,
On the soup to get it cool
And I blew to warm my hands."
"Get on your way at once!"
Exclaims the puzzled host
In most unseemly haste,
"The gods would vent their ire
On us if you sleep here.
A murrain on one whose breath
Blows hot and cold air both!"

# EDUCATION

Two puppies in some distant age
Sprang from the finest lineage:
Beauty and strength the heritage
Of Laridon and Caesar.

They fell to different owners. Then
One made the kitchen all his ken;
His brother haunted wood and glen:
Thus Laridon and Caesar.

They first had other nomenclature
Till nurture spoiled one vigorous nature:
A steward gave that altered creature
The name of Laridon.

His brother learned adventure's lore,
Brought stag to bay, battled the boar:
In canine history heretofore
There'd been no Caesar.

Since he was kept from loose affections
His sons acquired his perfections,
But any bitch could make connections
With lonely Laridon.

All over France we find that seed,
A faithless crew, abject in deed,
Polar opposites of the breed
Of valiant Caesar.

Sloth or some outward situation
Can cause a strain's degeneration,
Often, for want of cultivation
Caesars turn Laridon.

# THE MADMAN
## WHO SOLD WISDOM

Never have truck with lunacy:
This, I say, is the best of rules.
If you meet a madman turn and flee.
Many are found at court, where the king
Enjoys the barbs they sometimes fling
At sycophants, crooks, and fools.

A madman cried through the village squares
That he sold wisdom. A gullible throng
Gathered post-haste to sample his wares.
Few of the dupes could hide a grimace
When they got for their money a slap in the face
And a thread some three yards long.

Some got angry: that was absurd
And they were laughed at. Better to laugh
Oneself, or leave without saying a word,
Taking the piece of thread and the slap.
One would be hooted down for a sap
If one tried to make sense of the gaff.

Can logic pin down the circumstance
That causes dementia? A wounded brain
Works as it does by purest chance.
But smarting still from the slap and the thread,
One of the dupes took it into his head
To ask a sage to explain.

"That slap and that thread," were the sage's words,
"Are hieroglyphics. When he's abroad
A sensible man will keep three yards
Between himself and a fool, or he ought
To expect a blow. The wisdom you bought
From the madman was not a fraud."

# THE CAT AND THE RAT

Four different animals were wont
(Rascally spirits all) to haunt
The hollow trunk of an aged pine:
Milady weasel with the long waist line,
Grip-Cheese, the cat, Mesh-Munch, the rat,
And one owl, a fowl disconsolate.
So many gathered at this one site
That a man laid out some nets one night
Around the pine-tree. Early next day,
The cat set forth to stalk his prey.
He failed in the murky light of dawn
To spot the trap. He's caught! He's gone!
He sets up a howl of desperation.
The rat comes running in great elation
To see his most deadly of enemies
Caught in the toils. Then cries Grip-Cheese:
"Dear friend, the signs of your prodigality
Are numerous in my locality.
Come help me out of this trap where I fell
All unknowing. My heart did well
When, by some singular impulse, I
Made you the apple of my eye—
Sole among rats—and lavished my love.
I'm glad, I give thanks to the gods above
That I did. In fact I was going to prayers
Like a god-fearing cat, at dawn, and the snares
Snapped around me. My life's in your hands.
Dearest, come and undo these bands."

"What's in it for me?" inquired the rat
"I'll swear a deathless concordat
With you," said Grip-Cheese. "My very claws
Are at your service. You'll have no cause
To fear, I'll guard you from all reprisal,
I'll eat the owl-wife's mate and the weasel,
Whose feelings for you are distinctly cool."

At that the rat replied, "You fool!
I'd be a sucker to set you free!"
And he made for his hole in the old pine-tree.
There, the weasel was on the prowl,
So he climbed higher and met the owl.
Danger lurked wherever he turned.
'Twas the lesser evil — Mesh-munch adjourned
To the cat, and managed, bit by bit
To disengage the hypocrite.
Just then the trapper himself drew nigh,
So the new partnership had to fly.

<p align="center">*</p>

Later the cat saw the rat in the distance,
Alert and ready to make resistance;
"Brother," he said, "Come give me a kiss;
Your wariness of me I take amiss.
Do you see your former partner as foe?
Do you think that I could forget that I owe
My life, after God, to you." Said the rat,
"And I, do you think that I'd forget
Your nature? What pact gives the certitude
That a cat has a sense of gratitude?
Does anyone, indeed, rely
On covenants made of necessity?"

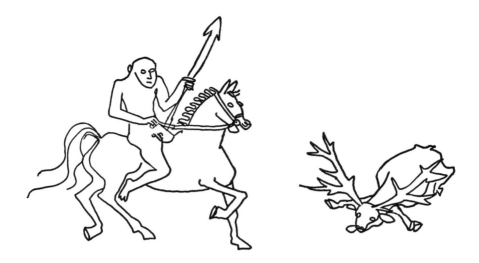

## THE HORSE'S REVENGE

Historically the horse's place
Was not to serve the human race.
When acorns were man's only foods
Horse, ass and mule could make the woods
Their home. And then one didn't see
As in the present century
So many saddles, so many packs,
So many carts, so many hacks,
So many trappings, so many gigs,
So many military rigs;
And along with fewer carriages
Went fewer feasts and marriages.

A horse sought vengeance, in the past,
Upon a stag, which went so fast
That he could never, on the run,
Be attacked by anyone.
Requiring more skill, the horse
To a human had recourse.
The man got reins and leaped astride,
Proceeding day and night to ride
Without repose, until the stag
Was overtaken by the nag.
When his enemy lay dead
The horse, to thank his helper, said:
"Your servant, sir. Farewell, I'll turn
Back to the woods where I sojourn."
The man demurred: "Now that we know
Your use, you're smarter not to go.
We'll treat you well if you will stay,
Keep you belly-deep in hay!"

Alas, what good is living high
If one has lost one's liberty?
The horse began to meditate
Upon this verity— too late.
His folly was not revocable,
Men were putting up the stable.
There he stayed and there he died,
Tether trailing at his side.
Would it not have made more sense
To forget the stag's offense?
Revenge, of course, is very nice
But too expensive if the price
Is that one blessing, lacking which
Nothing else can make you rich.

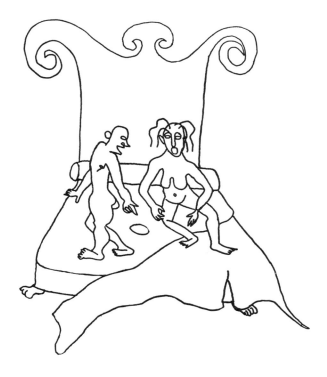

## WOMEN AND SECRETS

A secret's heavy, much too hard
For womanfolk to tote;
Even some men, in this regard,
Are female, I would note.

A man one night to test his wife
Exclaimed: "Oh, what a pain!
I cannot bear it. On my life,
I'm being torn in twain!

"My God, look here, I've laid an egg!"
"An egg?" "That's what, I reckon,
Still warm. Don't tell a soul, I beg,
Or I'll be called a chicken!"

She would not talk, she promised him,
'Fore God, she'd heed his warning
But his injunctions grew as dim
As night-shades in the morning.

By very nature not too subtle,
Or reticent, the spouse
Got out of bed at dawn to scuttle
Forth to her neighbor's house.

"Just wait, good woman, till you've heard
The tale I have to tell.
But promise not to say a word
Or I'll be beaten well.

"Just now my husband laid an egg
As big as four, and spherical!
But please, in heaven's name, don't wag
Your tongue about this miracle."

"Is that a joke?" the neighbor queried.
"No, I'm not humorsome!"
"Then get along, your secret's buried."
The egg-man's wife went home.

The neighbor woman burned to talk.
Instead of one egg, she
(In divers spots she went to walk)
Declared the man laid three.

So it began. Another dame
Said "Four!" Her undertone
Was needless, since by now his fame
Was very widely known.

As for the eggs, the gross amount
Increased as rumor thundered
From mouth to mouth, until the count
By evening passed one hundred.

# THE SNAKE
# AND THE FILE

They tell the story that a certain snake,
Living close by a man who used to make
Watches and clocks, ('twould seem a neighborhood
That for horologers was none too good)
One day in search of food entered the shop;
And finding nothing there by way of soup
Except an iron file, began to chew.
The file said kindly: "What do you mean to do,
Young ignoramus? You are tackling stuff
Harder than you. Your teeth will all break off
Before you get the fraction of a grain
From me, poor balmy serpent brain!
Only the fangs of time can eat a file."
This tale is meant for you, all spirits vile
Who, lacking talent, search without respite
For any object they can gnaw or bite.
Your industry is futile. Do you think
That on great masterpieces you can sink
Your blasphemous mark? No, they will be like bronze
Under your teeth, or steel or diamonds.

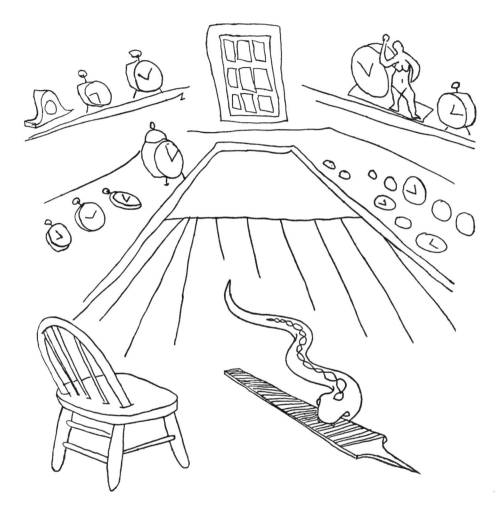

# THE HARE AND THE PARTRIDGE

Don't laugh at the poor: for who can be sure
That fate won't turn the tables?
Here's one example, and there are ample
Like it, in Aesop's fables.

<p style="text-align:center">*</p>

A partridge and hare are wont to share,
Co-citizens, one bright meadow,
In what seems to be a felicity
That nothing can overshadow.

But when there are sounds of a pack of hounds,
The hare must outwit the spry foe.
To a hide-out he races, and baffles the chase,
Even the hound named Brifaut.

But the odor that soars from the hot little pores
Of his body betray our hero;
One hound ponders well the provocative smell:
That is the hound named Miraut.

He concludes that the hare would make good fare
And presses him close with gusto
Till he's given the slip, as he hears from the lip
Of a candid hound named Rustaut.

The hare limps home to face his doom,
Poor thing, and die in his burrow.
The partridge, on meeting, gives this grim greeting
Without a sign of sorrow:

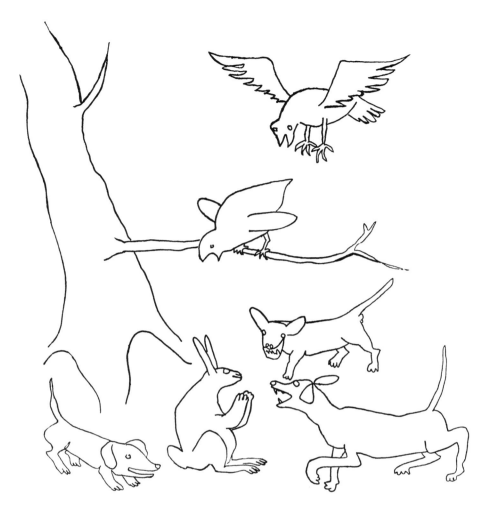

"Where were your feet? You said you were fleet.
Was that just sheer bravado?"
She was starting to laugh at her own mean gaff,
When she fell in an ambuscado.

She had thought, poor thing, she could flee on the wing
Any harm that could be done her,
Till too late she saw the merciless claw
Of a hawk that was right upon her.

# THE HORSE AND THE WOLF

A wolf, in springtime, when a gentle wind
Makes grasses come alive
And all the creatures leave their homes to find
Ways to survive,

A wolf, I say, perceives, when winter's through,
A horse put out to graze.
Fancy his joy! "To sink one's teeth in you,
Ah happy days!

Why aren't you sheep? I'll take you anyhow
Rather than lie in wait
For mutton, let us start manoeuvres now."
With measured gait

The wolf draws near and says he wields the art
Of great Hippocrates,
(Medicine, to you) and that he knows by heart
The properties

Of all the herbs that grow about this section,
And humbly makes the claim
That he can succor every affliction
That you could name.

If Master Steed would like to stanch some sickness,
He'd cure him—free, of course—
For by his book, it argued some great weakness,
A vagrant horse

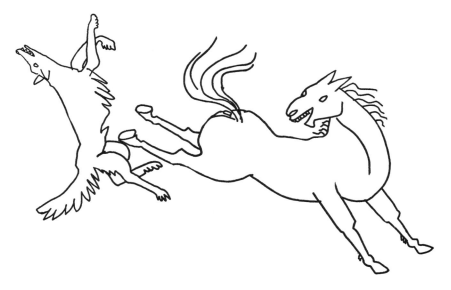

About the fields without a thing to do.
"I am inclined to suffer,
From a small ulcer of the foot, that's true,"
Replied the hoofer.

"That is a part where an inflamed condition
Is very apt to burgeon.
I serve the first horse-families as physician
As well as surgeon."

Playing for time, fearing to pounce in haste,
He failed, the false saw-bones,
To fool the horse, whose sudden kick made paste
Of his jaw-bones.

Wryly the wolf admitted: "That was clever—
Each to his own nature.
To ape the gardener was a fool's endeavour—
I'm just a butcher!"

# THE BEAR AND THE
# TWO CROOKS

Two fellow crooks, hard up for gold,
Went to a furrier friend and sold
Fur from a bear that wasn't dead.
They'd kill him later, so they said.
'Twas king of bears, they added: off it
A man could make a handsome profit.
The fiercest cold could not be felt
By someone wrapped in this fine pelt;
Furthermore Bruin's epidermis
Would make two coats, 'twas so enormous.
Shepherd Dindenaut, they swore,
Never prized his lambkins more
Than they the beast they claimed was theirs,
("theirs" by their own count, not the bear's.)
They'd bring the hide, was their proud boast,
In two days at the very most.
The deal is on, they fix the price,
Then go to hunt the merchandise.
But when he's sighted, trade's forgot.
The bear comes at them at a trot.
One climbs to the top of a nearby tree;
The other, like marble statuary,
Freezes, keels over on his nose,
Holds his breath in a corpse's pose,
Because he's heard a bear will never
Gormandize on a cadaver
That neither breathes nor moves a limb.

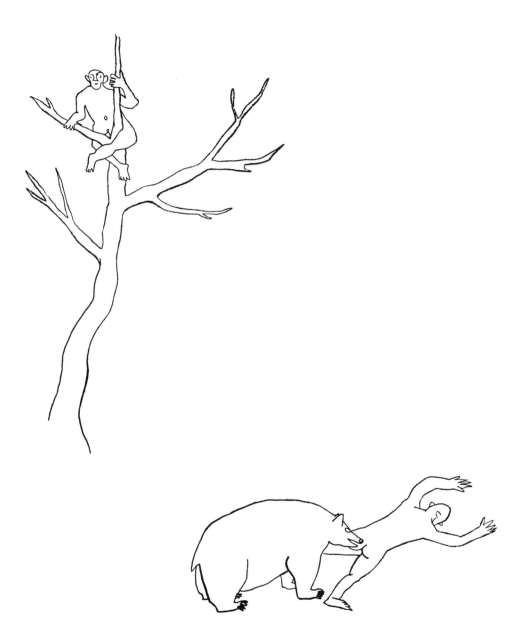

The noble bear, whose wits are dim,
Observes the human figure prone
And thinks, of course, all life is gone.
But lest there's trickery to discover
He carefully rolls the body over,
Nuzzles it, gives the nose a sniff.
"That," he says, "is quite some stiff!
It smells. I guess I'd better move."
He lumbers off to another grove.
One trader then sees fit to descend
Out of the tree. He runs to his friend.
"It's a wonder," he observes
"Unharmed except for frazzled nerves!
What of the pelt? When he came near,
What did the bear say in your ear?
When he pushed you with his snout,
What was he concerned about?"
"He said one should not sell a skin
Until the creature's been roped in!"

## THE MAN AND THE FLEA

With our unwelcome prayers
We tire the deity,
Often about affairs
Beneath our dignity.

Must heaven fix its gaze
And constantly remember
All the human race,
More than we can number?

Must men of mean condition
For every trivial boon,
And every small decision
Ceaselessly importune

Olympus, and the gods
That thereabouts deploy
As though it made the odds
Between great Greece and Troy?

A stupid fellow gets
A fleabite on the shoulder;
The flea thereafter lets
The fellow's sheets enfold her.

He cries to Hercules:
"The flea comes back with spring.
Purge thou the earth of this
Most horrifying thing!

Jupiter, from thy skies,
Avenge me, by thy grace.
Why dost thou not chastise
The flea's entire race?"

Just to slap down a flea
The fool required the gods
Lend their artillery
And thunder from the clouds.

A CATALOG OF SELECTED

# DOVER BOOKS

IN ALL FIELDS OF INTEREST

# A CATALOG OF SELECTED DOVER
# BOOKS IN ALL FIELDS OF INTEREST

DRAWINGS OF REMBRANDT, edited by Seymour Slive. Updated Lippmann, Hofstede de Groot edition, with definitive scholarly apparatus. All portraits, biblical sketches, landscapes, nudes. Oriental figures, classical studies, together with selection of work by followers. 550 illustrations. Total of 630pp. 9⅜ × 12¼.
21485-0, 21486-9 Pa., Two-vol. set $25.00

GHOST AND HORROR STORIES OF AMBROSE BIERCE, Ambrose Bierce. 24 tales vividly imagined, strangely prophetic, and decades ahead of their time in technical skill: "The Damned Thing," "An Inhabitant of Carcosa," "The Eyes of the Panther," "Moxon's Master," and 20 more. 199pp. 5⅜ × 8½. 20767-6 Pa. $3.95

ETHICAL WRITINGS OF MAIMONIDES, Maimonides. Most significant ethical works of great medieval sage, newly translated for utmost precision, readability. Laws Concerning Character Traits, Eight Chapters, more. 192pp. 5⅜ × 8½.
24522-5 Pa. $4.50

THE EXPLORATION OF THE COLORADO RIVER AND ITS CANYONS, J. W. Powell. Full text of Powell's 1,000-mile expedition down the fabled Colorado in 1869. Superb account of terrain, geology, vegetation, Indians, famine, mutiny, treacherous rapids, mighty canyons, during exploration of last unknown part of continental U.S. 400pp. 5⅜ × 8½. 20094-9 Pa. $6.95

HISTORY OF PHILOSOPHY, Julián Marías. Clearest one-volume history on the market. Every major philosopher and dozens of others, to Existentialism and later. 505pp. 5⅜ × 8½. 21739-6 Pa. $8.50

ALL ABOUT LIGHTNING, Martin A. Uman. Highly readable non-technical survey of nature and causes of lightning, thunderstorms, ball lightning, St. Elmo's Fire, much more. Illustrated. 192pp. 5⅜ × 8½. 25237-X Pa. $5.95

SAILING ALONE AROUND THE WORLD, Captain Joshua Slocum. First man to sail around the world, alone, in small boat. One of great feats of seamanship told in delightful manner. 67 illustrations. 294pp. 5⅜ × 8½. 20326-3 Pa. $4.95

LETTERS AND NOTES ON THE MANNERS, CUSTOMS AND CONDITIONS OF THE NORTH AMERICAN INDIANS, George Catlin. Classic account of life among Plains Indians: ceremonies, hunt, warfare, etc. 312 plates. 572pp. of text. 6⅛ × 9¼. 22118-0, 22119-9 Pa. Two-vol. set $15.90

ALASKA: The Harriman Expedition, 1899, John Burroughs, John Muir, et al. Informative, engrossing accounts of two-month, 9,000-mile expedition. Native peoples, wildlife, forests, geography, salmon industry, glaciers, more. Profusely illustrated. 240 black-and-white line drawings. 124 black-and-white photographs. 3 maps. Index. 576pp. 5⅜ × 8½. 25109-8 Pa. $11.95

THE ART NOUVEAU STYLE BOOK OF ALPHONSE MUCHA: All 72 Plates from "Documents Decoratifs" in Original Color, Alphonse Mucha. Rare copyright-free design portfolio by high priest of Art Nouveau. Jewelry, wallpaper, stained glass, furniture, figure studies, plant and animal motifs, etc. Only complete one-volume edition. 80pp. 9⅜ × 12¼. 24044-4 Pa. $8.95

ANIMALS: 1,419 COPYRIGHT-FREE ILLUSTRATIONS OF MAMMALS, BIRDS, FISH, INSECTS, ETC., edited by Jim Harter. Clear wood engravings present, in extremely lifelike poses, over 1,000 species of animals. One of the most extensive pictorial sourcebooks of its kind. Captions. Index. 284pp. 9 × 12. 23766-4 Pa. $9.95

OBELISTS FLY HIGH, C. Daly King. Masterpiece of American detective fiction, long out of print, involves murder on a 1935 transcontinental flight—"a very thrilling story"—NY Times. Unabridged and unaltered republication of the edition published by William Collins Sons & Co. Ltd., London, 1935. 288pp. 5⅜ × 8½. (Available in U.S. only) 25036-9 Pa. $4.95

VICTORIAN AND EDWARDIAN FASHION: A Photographic Survey, Alison Gernsheim. First fashion history completely illustrated by contemporary photographs. Full text plus 235 photos, 1840–1914, in which many celebrities appear. 240pp. 6½ × 9¼. 24205-6 Pa. $6.00

THE ART OF THE FRENCH ILLUSTRATED BOOK, 1700–1914, Gordon N. Ray. Over 630 superb book illustrations by Fragonard, Delacroix, Daumier, Doré, Grandville, Manet, Mucha, Steinlen, Toulouse-Lautrec and many others. Preface. Introduction. 633 halftones. Indices of artists, authors & titles, binders and provenances. Appendices. Bibliography. 608pp. 8⅜ × 11¼. 25086-5 Pa. $24.95

THE WONDERFUL WIZARD OF OZ, L. Frank Baum. Facsimile in full color of America's finest children's classic. 143 illustrations by W. W. Denslow. 267pp. 5⅜ × 8½. 20691-2 Pa. $5.95

FRONTIERS OF MODERN PHYSICS: New Perspectives on Cosmology, Relativity, Black Holes and Extraterrestrial Intelligence, Tony Rothman, et al. For the intelligent layman. Subjects include: cosmological models of the universe; black holes; the neutrino; the search for extraterrestrial intelligence. Introduction. 46 black-and-white illustrations. 192pp. 5⅜ × 8½. 24587-X Pa. $6.95

THE FRIENDLY STARS, Martha Evans Martin & Donald Howard Menzel. Classic text marshalls the stars together in an engaging, non-technical survey, presenting them as sources of beauty in night sky. 23 illustrations. Foreword. 2 star charts. Index. 147pp. 5⅜ × 8½. 21099-5 Pa. $3.50

FADS AND FALLACIES IN THE NAME OF SCIENCE, Martin Gardner. Fair, witty appraisal of cranks, quacks, and quackeries of science and pseudoscience: hollow earth, Velikovsky, orgone energy, Dianetics, flying saucers, Bridey Murphy, food and medical fads, etc. Revised, expanded In the Name of Science. "A very able and even-tempered presentation."—The New Yorker. 363pp. 5⅜ × 8. 20394-8 Pa. $6.50

ANCIENT EGYPT: ITS CULTURE AND HISTORY, J. E Manchip White. From pre-dynastics through Ptolemies: society, history, political structure, religion, daily life, literature, cultural heritage. 48 plates. 217pp. 5⅜ × 8½. 22548-8 Pa. $4.95

CHRISTMAS CUSTOMS AND TRADITIONS, Clement A. Miles. Origin, evolution, significance of religious, secular practices. Caroling, gifts, yule logs, much more. Full, scholarly yet fascinating; non-sectarian. 400pp. 5⅜ × 8½.
23354-5 Pa. $6.50

THE HUMAN FIGURE IN MOTION, Eadweard Muybridge. More than 4,500 stopped-action photos, in action series, showing undraped men, women, children jumping, lying down, throwing, sitting, wrestling, carrying, etc. 390pp. 7⅞ × 10⅝.
20204-6 Cloth. $19.95

THE MAN WHO WAS THURSDAY, Gilbert Keith Chesterton. Witty, fast-paced novel about a club of anarchists in turn-of-the-century London. Brilliant social, religious, philosophical speculations. 128pp. 5⅜ × 8½.
25121-7 Pa. $3.95

A CEZANNE SKETCHBOOK: Figures, Portraits, Landscapes and Still Lifes, Paul Cezanne. Great artist experiments with tonal effects, light, mass, other qualities in over 100 drawings. A revealing view of developing master painter, precursor of Cubism. 102 black-and-white illustrations. 144pp. 8¾ × 6⅝.
24790-2 Pa. $5.95

AN ENCYCLOPEDIA OF BATTLES: Accounts of Over 1,560 Battles from 1479 B.C. to the Present, David Eggenberger. Presents essential details of every major battle in recorded history, from the first battle of Megiddo in 1479 B.C. to Grenada in 1984. List of Battle Maps. New Appendix covering the years 1967–1984. Index. 99 illustrations. 544pp. 6½ × 9¼.
24913-1 Pa. $14.95

AN ETYMOLOGICAL DICTIONARY OF MODERN ENGLISH, Ernest Weekley. Richest, fullest work, by foremost British lexicographer. Detailed word histories. Inexhaustible. Total of 856pp. 6½ × 9¼.
21873-2, 21874-0 Pa., Two-vol. set $17.00

WEBSTER'S AMERICAN MILITARY BIOGRAPHIES, edited by Robert McHenry. Over 1,000 figures who shaped 3 centuries of American military history. Detailed biographies of Nathan Hale, Douglas MacArthur, Mary Hallaren, others. Chronologies of engagements, more. Introduction. Addenda. 1,033 entries in alphabetical order. xi + 548pp. 6½ × 9¼. (Available in U.S. only)
24758-9 Pa. $11.95

LIFE IN ANCIENT EGYPT, Adolf Erman. Detailed older account, with much not in more recent books: domestic life, religion, magic, medicine, commerce, and whatever else needed for complete picture. Many illustrations. 597pp. 5⅜ × 8½.
22632-8 Pa. $8.95

HISTORIC COSTUME IN PICTURES, Braun & Schneider. Over 1,450 costumed figures shown, covering a wide variety of peoples: kings, emperors, nobles, priests, servants, soldiers, scholars, townsfolk, peasants, merchants, courtiers, cavaliers, and more. 256pp. 8⅜ × 11¼.
23150-X Pa. $7.95

THE NOTEBOOKS OF LEONARDO DA VINCI, edited by J. P. Richter. Extracts from manuscripts reveal great genius; on painting, sculpture, anatomy, sciences, geography, etc. Both Italian and English. 186 ms. pages reproduced, plus 500 additional drawings, including studies for *Last Supper, Sforza* monument, etc. 860pp. 7⅞ × 10¾. (Available in U.S. only) 22572-0, 22573-9 Pa., Two-vol. set $25.90

AMERICAN CLIPPER SHIPS: 1833–1858, Octavius T. Howe & Frederick C. Matthews. Fully-illustrated, encyclopedic review of 352 clipper ships from the period of America's greatest maritime supremacy. Introduction. 109 halftones. 5 black-and-white line illustrations. Index. Total of 928pp. 5⅜ × 8½.
25115-2, 25116-0 Pa., Two-vol. set $17.90

TOWARDS A NEW ARCHITECTURE, Le Corbusier. Pioneering manifesto by great architect, near legendary founder of "International School." Technical and aesthetic theories, views on industry, economics, relation of form to function, "mass-production spirit," much more. Profusely illustrated. Unabridged translation of 13th French edition. Introduction by Frederick Etchells. 320pp. 6⅛ × 9¼. (Available in U.S. only)
25023-7 Pa. $8.95

THE BOOK OF KELLS, edited by Blanche Cirker. Inexpensive collection of 32 full-color, full-page plates from the greatest illuminated manuscript of the Middle Ages, painstakingly reproduced from rare facsimile edition. Publisher's Note. Captions. 32pp. 9⅜ × 12¼.
24345-1 Pa. $4.95

BEST SCIENCE FICTION STORIES OF H. G. WELLS, H. G. Wells. Full novel *The Invisible Man*, plus 17 short stories: "The Crystal Egg," "Aepyornis Island," "The Strange Orchid," etc. 303pp. 5⅜ × 8½. (Available in U.S. only)
21531-8 Pa. $4.95

AMERICAN SAILING SHIPS: Their Plans and History, Charles G. Davis. Photos, construction details of schooners, frigates, clippers, other sailcraft of 18th to early 20th centuries—plus entertaining discourse on design, rigging, nautical lore, much more. 137 black-and-white illustrations. 240pp. 6⅛ × 9¼.
24658-2 Pa. $5.95

ENTERTAINING MATHEMATICAL PUZZLES, Martin Gardner. Selection of author's favorite conundrums involving arithmetic, money, speed, etc., with lively commentary. Complete solutions. 112pp. 5⅜ × 8½. 25211-6 Pa. $2.95

THE WILL TO BELIEVE, HUMAN IMMORTALITY, William James. Two books bound together. Effect of irrational on logical, and arguments for human immortality. 402pp. 5⅜ × 8½. 20291-7 Pa. $7.50

THE HAUNTED MONASTERY and THE CHINESE MAZE MURDERS, Robert Van Gulik. 2 full novels by Van Gulik continue adventures of Judge Dee and his companions. An evil Taoist monastery, seemingly supernatural events; overgrown topiary maze that hides strange crimes. Set in 7th-century China. 27 illustrations. 328pp. 5⅜ × 8½. 23502-5 Pa. $5.95

CELEBRATED CASES OF JUDGE DEE (DEE GOONG AN), translated by Robert Van Gulik. Authentic 18th-century Chinese detective novel; Dee and associates solve three interlocked cases. Led to Van Gulik's own stories with same characters. Extensive introduction. 9 illustrations. 237pp. 5⅜ × 8½.
23337-5 Pa. $4.95

*Prices subject to change without notice.*

Available at your book dealer or write for free catalog to Dept. GI, Dover Publications, Inc., 31 East 2nd St., Mineola, N.Y. 11501. Dover publishes more than 175 books each year on science, elementary and advanced mathematics, biology, music, art, literary history, social sciences and other areas.